ACRYLIC
MADE
EASY

STILL LIFES

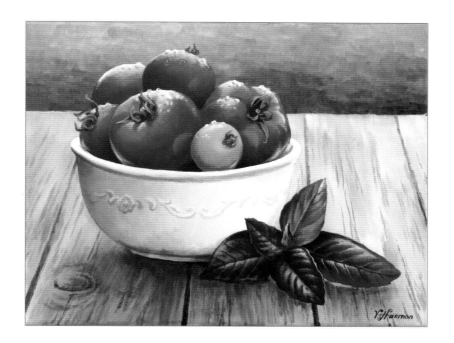

Varvara Harmon

Quarto is the authority on a wide range of topics.
Quarto educates, entertains, and enriches the lives of our readers—
enthusiasts and lovers of hands-on living.
www.quartoknows.com

© 2014 Quarto Publishing Group USA Inc.
Published by Walter Foster Publishing, a division of Quarto Publishing Group USA Inc.
All rights reserved. Walter Foster is a registered trademark.
Artwork and photographs © 2014 Varvara Harmon, except: Photographs on pages 5 ("Paints") and
7 ("Easels") © 2012 Vanessa Rothe. Photographs on pages 9 and 11 (color wheels) © Shutterstock.
Artwork on page 8 © Nathan Rohlander, except "Wet-into-Wet" © Tom Swimm.

6 Orchard Road, Suite 100
Lake Forest, CA 92630
quartoknows.com
Visit our blogs at quartoknows.com

Printed in China
3 5 7 9 10 8 6 4

CONTENTS

INTRODUCTION

Painting with acrylics provides an artist with nearly endless creative possibilities. Acrylic paints allow you to use a wide variety of techniques to achieve any desired effect. There are so many wonderful ways to approach painting with this medium!

This book is designed for beginners and for artists who want to improve their skills or try out new techniques. Inside, you will explore a variety of styles through a series of still life lessons, from very detailed and realistic styles to more loose, impressionistic styles. Comprehensive, step-by-step instruction will lead you through each part of the painting process. Still life subjects are very useful in helping artists recognize and practice the forms and values needed to create three-dimensional paintings. Gray- or brown-scale underpaintings are also utilized in this book; they are a great exercise for studying value (light to dark). Underpaintings also assist the artist in better understanding the direction and intensity of light sources, seeing the variety of shades in shadows, and ultimately developing a heightened sense of space and depth when painting.

Once you understand these essential concepts, any still life composition you dream up can become an enjoyable subject to paint!

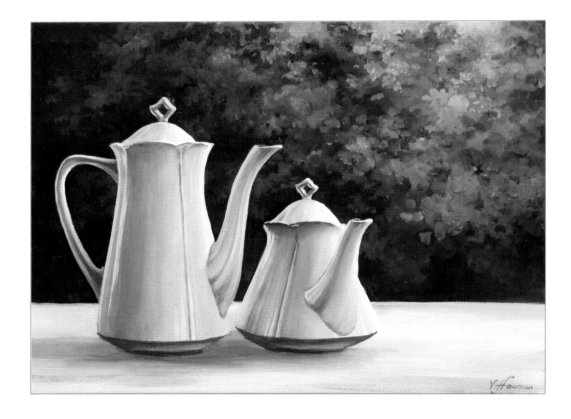

TOOLS & MATERIALS

To get started with acrylic, you need only a few basic tools. When you buy supplies, try to purchase the best quality you can afford. Better-quality materials are more manageable and produce longer-lasting works.

Paint

Acrylic paint has great quality and depth and comes in a wide variety of colors. It is easy to use, can be mixed with water, is nontoxic, and cleans up easily. Take your time getting to know this medium. Play around with it to understand its consistency and drying time. There are many brands of high-quality paints to choose from and I recommend you purchase the highest quality you can afford. I use a relatively limited palette that allows me to create many color combinations and shades. My color palette contains alizarin crimson, burnt sienna, cadmium red medium, cadmium yellow light, cadmium yellow medium, cerulean blue, pine gray, raw umber, sap green, titanium white, ultramarine blue, and yellow ochre.

Painting Surfaces

I use a wide variety of surfaces for my paintings—stretched canvas, canvas board, gesso board, watercolor paper, and watercolor board. For painting with heavier strokes, I prefer to work on well-primed, commercially prepared and stretched canvas or primed gessoboard. For painting with glazing techniques, I use 300-lb. watercolor paper or watercolor board. Watercolor paper is available hot pressed or cold pressed. Hot-pressed watercolor paper has a fine-grained, smooth surface, with almost no *tooth*, or texture. This surface is great for glazing and washing techniques, where you do not want to see the texture of the paper. Cold-pressed watercolor paper has a textured surface, which creates a grainy effect. Use this surface to show texture in your painting.

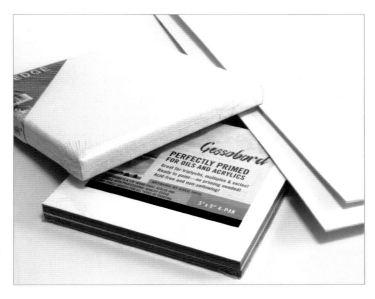

Palette

There are many acrylic palettes available on the market. It is very important to keep acrylics moist while you are working on the painting. For that reason, I prefer a "stay-wet" palette. It has a foam pad that keeps the palette wet and your paints moist. When you are done with a painting session, you can seal the palette to protect the paint from drying and keep it usable for a few days.

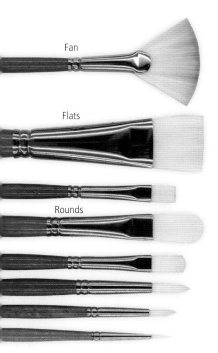

Fan

Flats

Rounds

Brushes

There is a wide range of acrylic paintbrushes designed specifically for this medium. The quality of your brushes is important for achieving the best results, so buy the best brushes that you can afford. It's okay to start out with more affordable brushes and upgrade as you get more comfortable with the medium. Here are several brush shapes that I use:

Round brushes are good for touch-ups and more detailed work.

Flat or *filbert* brushes hold plenty of paint and are good for applying thick layers. Both flat and filbert brushes are great for painting large surface areas, as well as creating thin, straight lines. These brushes are useful for blending colors and creating well-defined brushstrokes on your surface.

A *fan* brush has a flat profile, spread like a fan. This brush is ideal for creating patterned textures or wispy lines.

Cleaning Your Brushes

Having the right brush is essential, but it is equally important to keep your brushes in good shape. When you are done using your paintbrush, make sure you wipe off any excess paint with a painting rag or paper towel. Rinse your brush in lukewarm water with soap or brush cleaner. Make sure the water temperature isn't too hot, as this can damage the brush. It is important to clean your brushes thoroughly. If you fail to remove all of the excess paint, it will dry on the filaments of your brushes and the bristles will stiffen. Washing your brushes properly will help them last much, much longer.

Easels

You will need a simple easel to hold your canvas in place as you paint. Acrylic paintings are usually painted with the canvas tilted at a slight backward angle (about 15 to 20 degrees). It's important that your easel has a clamp at the top and a holder on the bottom. A good choice is a box easel that can hold a rectangular palette, brushes, and paints inside. If you prefer, you can use a tabletop or a standing French easel, with legs that fold out like a tripod.

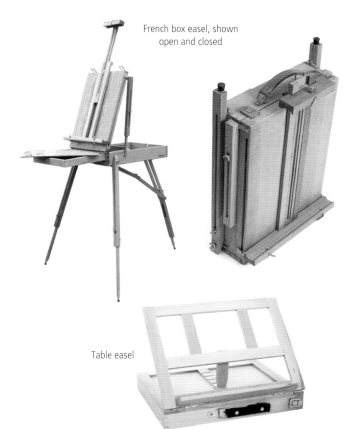

French box easel, shown open and closed

Table easel

Additional Supplies

Some additional supplies you'll want to have on hand include: paper towels or painting rags to clean and dry the brushes; paper and pencils for drawing, sketching, and tracing; an eraser; and a bowl or jar of water to rinse your brushes. You may want to have a toothbrush, palette knife, and sponge available for creating special effects, removable tape for protecting areas of your paintings, and artist tape to secure watercolor paper to hard surfaces. I also recommend masking fluid to preserve the white areas of your paper when you paint using the watercolor technique, as well as a retarder to increase the working time of your paints. Lastly, I like to keep a plastic card, such as an old credit card, on hand to use for scraping paint.

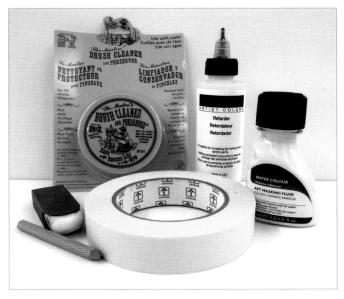

ACRYLIC TECHNIQUES

Basic Techniques

There are a myriad of techniques and tools that can be used to create a variety of textures and effects. By employing some of these assorted techniques, you can spice up your art and keep the painting process fresh, exciting, and fun!

Flat Wash This thin mixture of acrylic paint has been diluted with water. Lightly sweep overlapping, horizontal strokes across the support.

Graded Wash Add more water and less pigment as you work your way down. Graded washes are great for creating interesting backgrounds.

Drybrush Use a worn flat or fan brush loaded with thick paint, wipe it on a paper towel to remove moisture, and then apply it to the surface using quick, light, irregular strokes.

Mask with Tape Masking tape can be placed onto dried acrylic paint and removed without causing damage. Don't paint too thickly on the edges—you won't get a clean lift.

Lifting Out Use a moistened brush or tissue to press down and lift colors out of a wet wash. If the wash is dry, wet the desired area and lift out paint with a paper towel.

Wet-into-Wet Apply a color next to another that is still wet. Blend the colors by stroking them together where they meet, and use your brush to soften the edges to produce smooth transitions.

GUIDE TO COLOR

Painting is a way of communicating with the world, and no part of that communication is more important than color. Color variations create shape and form, giving your subject dimension. Color also creates mood and evokes emotion, allowing the viewer to connect with the painting. But to unlock the full potential of color, you must first become familiar with a few color basics.

Seeing the Spectrum

Unless you plan to work with just one color, color relationships are important. The color wheel helps us visualize these relationships. The three main colors of the wheel are red, yellow, and blue. All other colors derive from these three *primary* colors. Mixing two primary colors yields a *secondary* color (green, orange, or purple). Mixing a primary and a secondary color produces a *tertiary* color, such as blue-green. The wheel shows closely related colors next to each other; these are *analogous* colors. It also shows opposite colors; these *complementary* colors make each other really stand out.

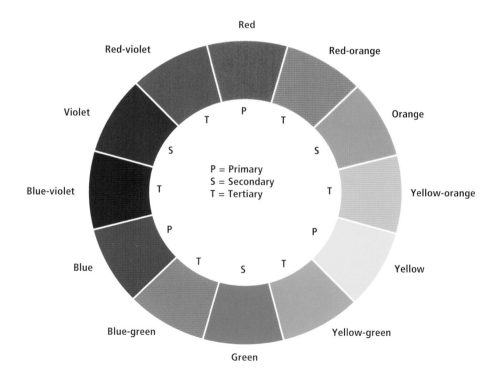

The Color Wheel This simple color reference wheel is a useful tool. It's an at-a-glance guide to mixing basic colors and can be used as a quick way to identify strong color pairings.

Seeing Values

The world isn't black and white; there are many shades of gray. Every one of these shades, from dark to light, has its own value. We manipulate the arrangement of values to create light, shadow, and dimension in paintings, and sometimes even to create drama. To create balance in your composition, you can plan ahead by creating a value sketch, either with pencil on paper or with paint on canvas, using pure paint (the darkest value) and adding white (or water) to create lighter values.

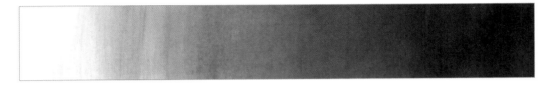

Below are first two essential steps to begin a painting. The first step is the drawing; sometimes it's difficult to see what the drawing represents. However, in the second step, the value painting, you can clearly see the shape of the folds.

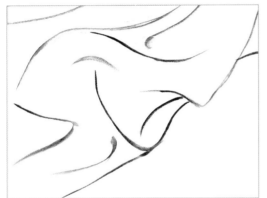 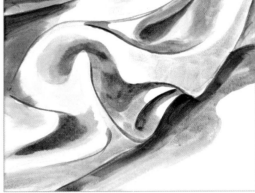

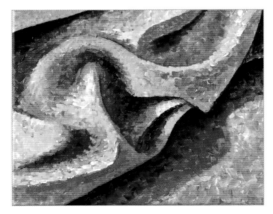

Adding color to a value painting to complete the image is much easier than working with a simple sketch.

Changing the Temperature

The color wheel is also divided by temperature, with warm colors (red, orange, and yellow) on one side and cool colors (blue, green, and purple) on the opposite. Warm colors come forward in a painting, making them ideal for objects in the foreground. Cool colors appear to recede into the distance. Although every color is either warm or cool, it can also have variations. For example, you can have a cool red or a warm red, depending on whether it is more blue-toned or yellow-toned. We associate warm colors with summer and midafternoon, as well as passionate emotions, energy, and excitement. Cool colors represent winter and early morning, and they tend to make us feel mellow, quiet, or subdued. You can apply these associations of color to create dimension and elicit emotion as you paint.

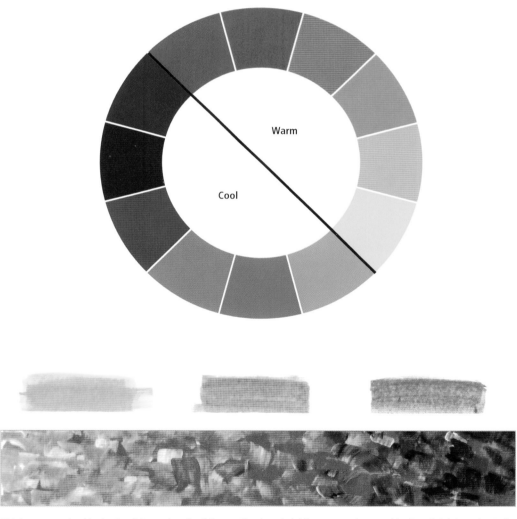

Pink is a warm color; it's simply a lighter value of red. But a yellow-based pink is warmer, whereas a blue-based pink is cooler. Each conveys a slightly different mood.

USING COMPLEMENTARY COLORS

Even the simplest of subjects can attract the eye when you use color to your advantage. Highlights and shadows come alive with natural variations in color. The use of complementary colors transforms that excitement into high drama. Here, the warm golden aspects of yellow highlights come to life when juxtaposed against a cool blue background, while blue shadows pop against a deep burnt sienna backdrop.

Step 1 I like to work on a clean canvas, without extra lines left over from working out my initial sketch. So I draw my subject on paper first, using a 12" x 16" sheet that matches my canvas so I can get a true feel for the proportions and composition. When I'm satisfied with my sketch, I trace the finished product on my canvas.

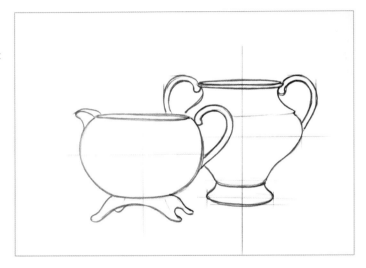

Step 2 After transferring my sketch, I establish the values of the composition and the colors of the subject and background. I apply loose, imprecise strokes of thinned ultramarine blue and burnt sienna, allowing the colors to overlap and blend. I favor the neutral brown, so as not to detract from the central focus of the painting. This underpainting can be imperfect. We'll refine the details in subsequent layers.

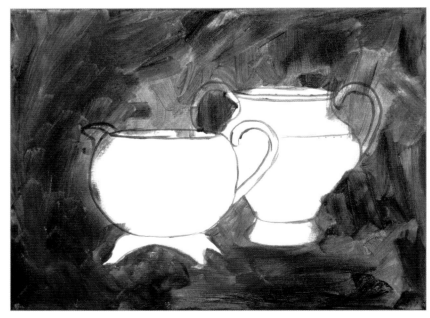

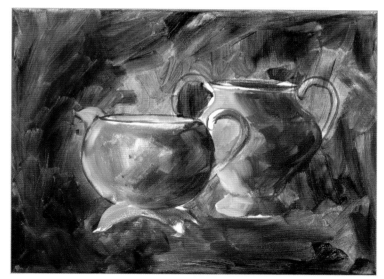

Step 3 Next I fill in the basic shapes of my subject in the same loose manner, again using water-thinned burnt sienna and ultramarine blue, but this time favoring blue for a blue-gray result. Although the background and objects have the same color combination, this change in color dominance will draw the eye toward the subject, which is lighter and thus attracts more interest.

Step 4 With the first layer of color complete, I begin painting the larger pitcher, this time using a thicker application with short, multi-directional strokes that give the pitcher its rounded form. I begin with the lightest area, stroking in a mixture of titanium white and cadmium yellow medium, adding more and more burnt sienna as I reach the shadowed portions of the pitcher. (See detail.)

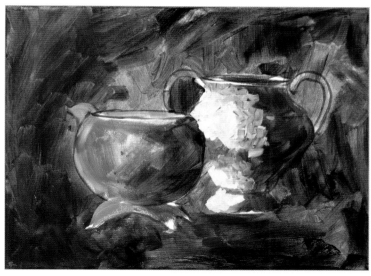

DETAIL

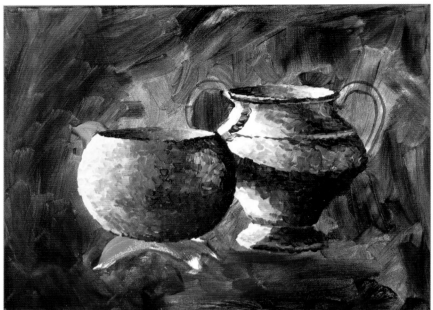

Step 5 I complete the deeper shadows on the far right side of the larger pitcher with a combination of pine gray and ultramarine blue. Next I apply the highlight areas on top of the shadow; both cooler and darker than the light areas on the opposite side of the vase, these reflections are a mix of ultramarine blue and titanium white. Once the majority of the larger pitcher's shape is complete, I paint its companion in the exact same fashion.

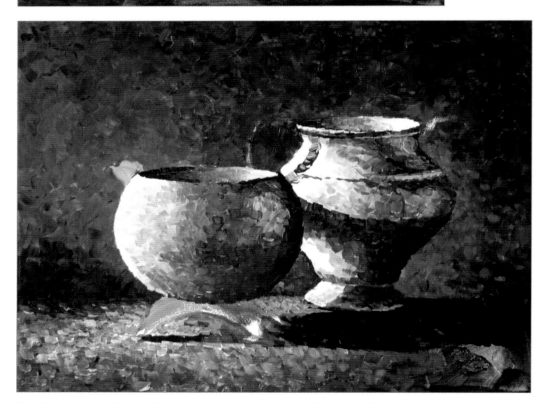

Step 6 Now I turn my attention to the background, using short, thick strokes of ultramarine blue combined with burnt sienna and pine gray. On the left of the canvas, I complement the light yellow area of the pitcher by touching in blue-gray highlights. On the right, I work in reverse, complementing cooler blues with more burnt sienna. For the table, I work from light to dark, starting at the left with white, yellow, and burnt sienna; I gradually add more ultramarine blue and pine gray as I move right.

DETAIL

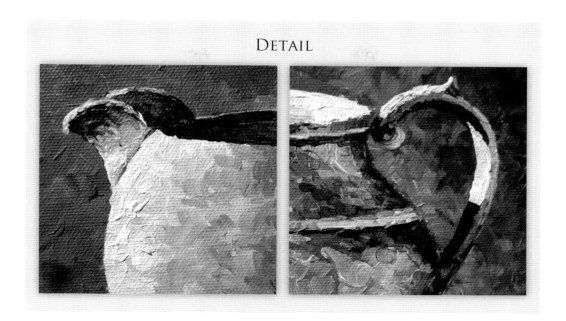

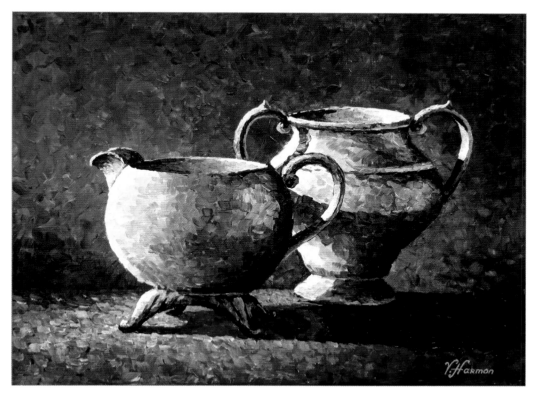

Step 7 Now it's time for the detail work: the spout, handles, and legs. The color palette remains the same as in previous steps, with both lighter and darker applications to create dimension and form, and warmer and cooler paint mixtures for highlights and shadows.

WORKING FROM LIFE

One of the biggest advantages to working with a live subject instead of a photograph is the ability to physically manipulate it. Instead of using artistic license to edit your subject on paper, you can actually play with the elements of your still life—adding or removing items, shifting objects, or changing the lighting. This is especially nice with flower arrangements, such as this vase of lilies, which I placed against draped fabric near a window.

Palette
alizarin crimson • burnt sienna • cadmium yellow medium • pine gray • sap green • titanium white • ultramarine blue

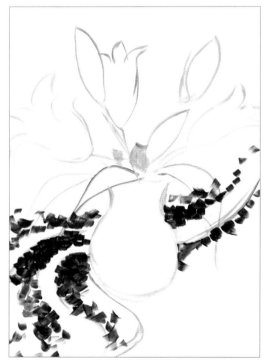

Step 1 I make a few loose sketches of my still life on paper and choose the most pleasing as a model for my loose draft on canvas. I establish the composition with sap green, adding a bit ultramarine blue in darker spots. Then I use a mixture of ultramarine blue and sap green to paint along the curve of the deepest folds in the fabric, where the shadows lie. Doing so helps me establish the direction of the folds for subsequent work.

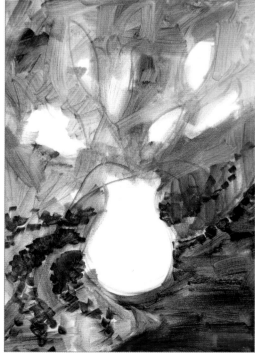

Step 2 Next I apply broad, loose strokes to establish the colors of my background while mapping its values. I paint over the folds from the previous step with sap green and ultramarine blue—but this new layer of paint is thinned with water so that the previous layer remains visible underneath. I also establish the table with a combination of thinned burnt sienna and a hint of ultramarine blue.

MIXING ON CANVAS

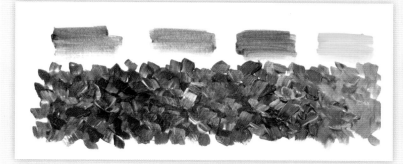

By overlapping strokes of different colors, you can create natural-looking color mixtures. This technique is also ideal for making transitions from lighter to darker areas or to smoothly transition from cool to warm.

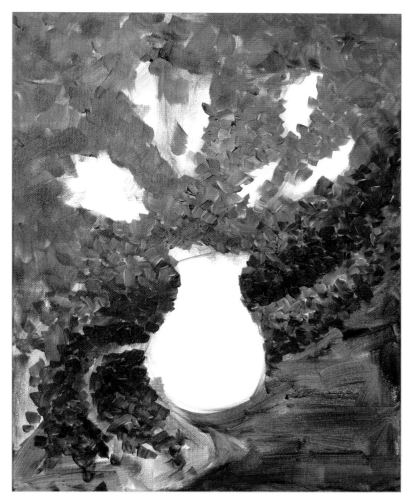

Step 3 For the fabric, I use sap green and ultramarine blue, adding cadmium yellow medium for the warmer areas in the top right corner. For the shadowed areas of the folds, I add a little pine gray for a cool, blue-dominant result. Instead of mixing paint directly, I make transitions by overlapping strokes of different colors. (See "Mixing on Canvas" above.)

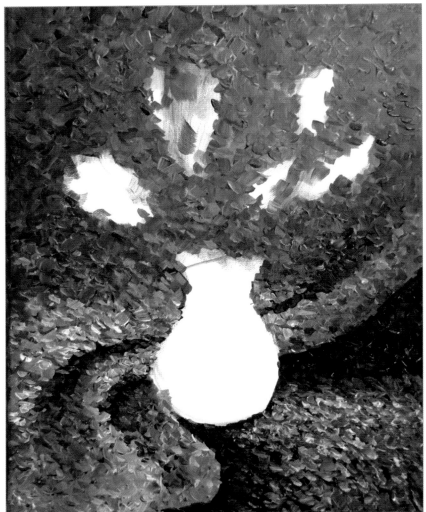

Step 4 I continue building up the background to my desired light sage-gray result. The underpainted colors and layered mixing technique provide life and interest. I turn my attention to the table, using the ultramarine blue and burnt sienna combination of the underpainting for a warm brown on the table, this time with short thick strokes. I lighten up highlights by adding cadmium yellow medium, and I keep the eye from drifting off the canvas by applying more blue in the right corner, strengthening the composition while establishing an area of shadow.

DETAIL

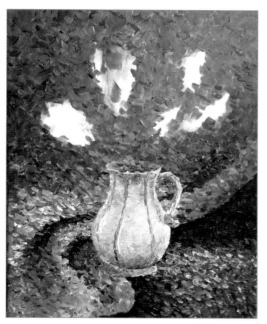

Step 5 Although the vase is white, it reflects the brown from the table and the blue-green of the fabric folds. Adding blue to the shadows and yellow to the highlights of the white vase help define its shape, giving it dimension rather than a flat appearance. I render the details of the vase's body and handle with the same color combinations.

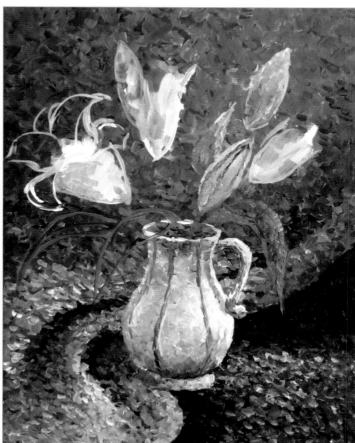

Step 6 My original sketch has been covered by background strokes, so I take a moment to redefine the outline of flowers and leaves in appropriate colors, eliminating some of the leaves to avoid overcrowding the focal point. I loosely fill the outlines of the leaves and flower buds with strokes of sap green, ultramarine blue, and burnt sienna, applying titanium white and a bit of alizarin crimson at the base of the buds. I establish the base of the flowering lilies with the same white and crimson mixture.

19

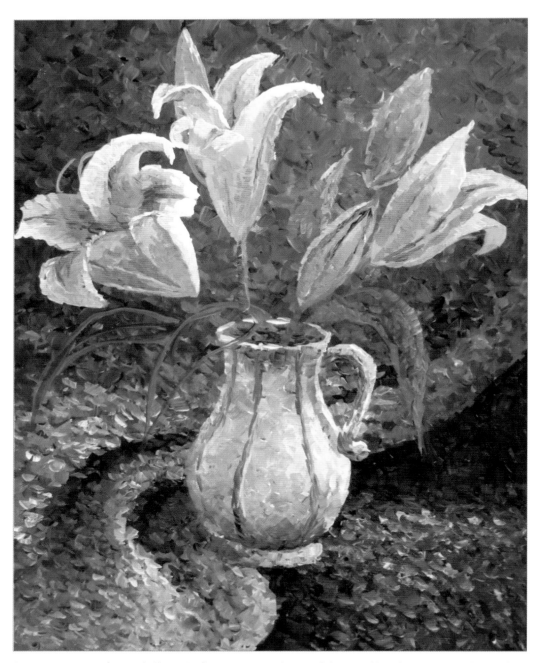

Step 7 Now I turn my focus to the blossoming flowers, using a combination of ultramarine blue, alizarin crimson, cadmium yellow medium, and titanium white to create shape and form. In shaded areas, I add more blue for a cooling effect; in lighter areas, I favor yellow to show light and warmth.

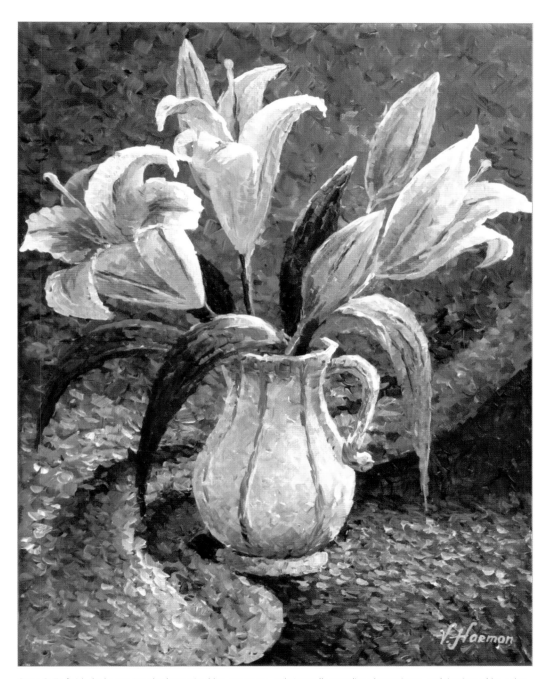

Step 8 To finish the leaves, I apply ultramarine blue, sap green, cadmium yellow medium, burnt sienna, and titanium white, using more white and yellow in the highlights and more blue in the shadows. I also decide to add some colors from the lilies on both the vase and the draped fabric, applying crimson and white to reflect the flowers.

REFLECTING COLOR

It makes sense that metal objects mirror their surroundings, but people are often surprised that white objects similarly reflect color—an effect that makes them very compelling. Because the background and objects that accompany the white focal point will influence its appearance, it's important to consider their color composition when planning your still life. The "white" china cup in this still life comes to life when warm yellow-browns pair with complementary cool blues.

Palette
burnt sienna • pine gray • sap green • titanium white • ultramarine blue • yellow ochre

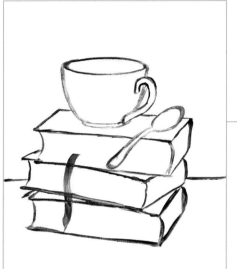

Step 1 On a 14" x 11" canvas, I work out my composition with a graphite pencil so I can make changes and corrections. When I'm happy with what I see, I outline the drawing with gray paint to keep my guide visible when I start applying color.

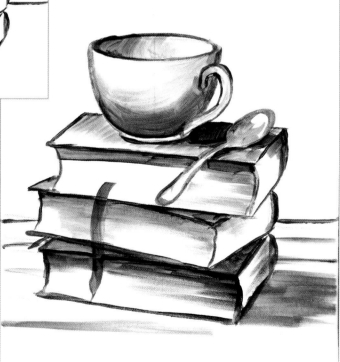

Step 2 I plan the balance of light and dark with a value sketch to avoid a washed-out painting. My focal point is a white cup, but that doesn't mean it's entirely light in value. I work out my shadows in thinned gray paint for a guide.

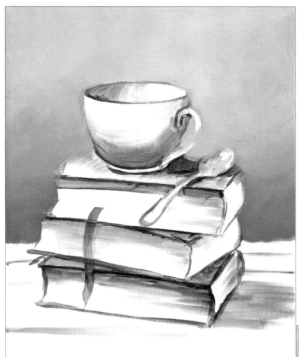

Step 3 I start with the back wall, which sets the tone of the painting, combining burnt sienna, yellow ochre, and ultramarine blue with a small amount of sap green. As I move into the shaded areas, I add more blue and green for a cooling effect.

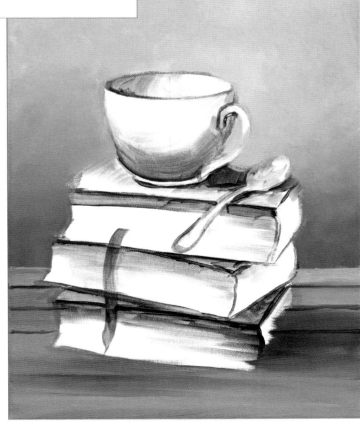

Step 4 I use similar colors on the the table, but for a warmer palette, I mix in more yellow ochre and less blue and green. For the shadow beside the books, I add more blue. I paint lines between the boards using burnt sienna mixed with ultramarine blue.

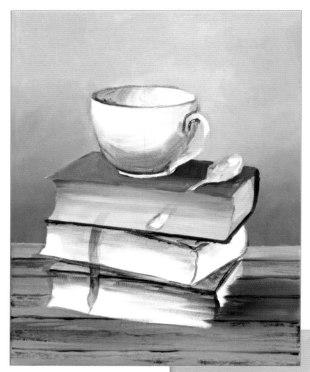

Step 5 For a wood-grain effect, I load a ½" brush with a mix of burnt sienna and ultramarine blue before lightly dragging it across the table. I combine burnt sienna, yellow ochre, and ultramarine blue for the book pages, adding gray for contrasting shadows. The cover is ultramarine blue mixed with titanium white, sap green, and pine gray.

Step 6 I painted the top book to set the ground for my cup, but I'll establish the focal point before attending to the others. Mindful of the light source on the left, I reserve pure white for the directly lit portions of the cup on the outer left and inner right. I mix the shadows inside the cup with titanium white and the background's brown. I paint the shadows on the outside with titanium white and the book's blue.

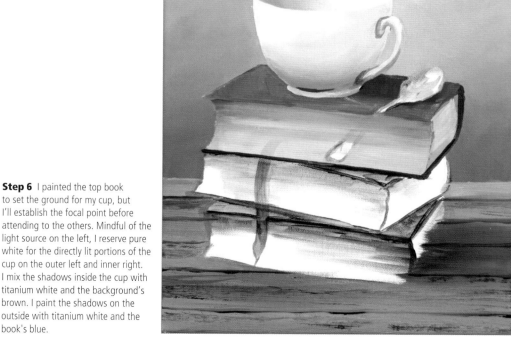

24

Step 7 I continue layering on the cup until I've covered the value sketch shadow on the handle and lower portion of the bowl. Then I turn my attention back to the books, layering the same mix from step 5 over all the pages and then adding shadows—including the deep one under the top cover—by mixing in gray.

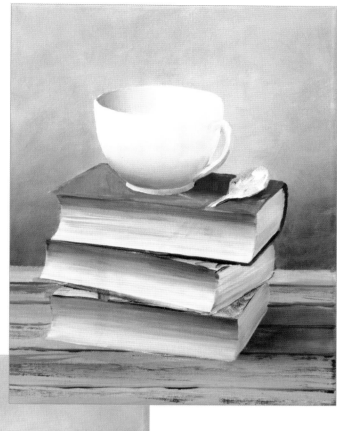

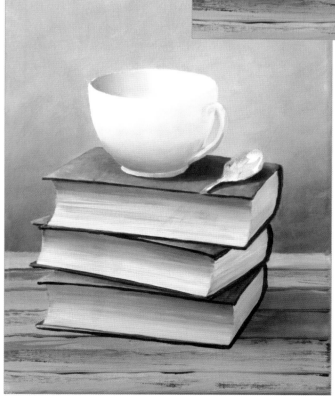

Step 8 With the pages firmly established, I turn my attention to the remaining book covers, applying the same mixture of ultramarine blue, titanium white, sap green, and pine gray. In addition to painting the lower book covers, I once again layer over the top cover, mixing in more gray where the cup casts a shadow.

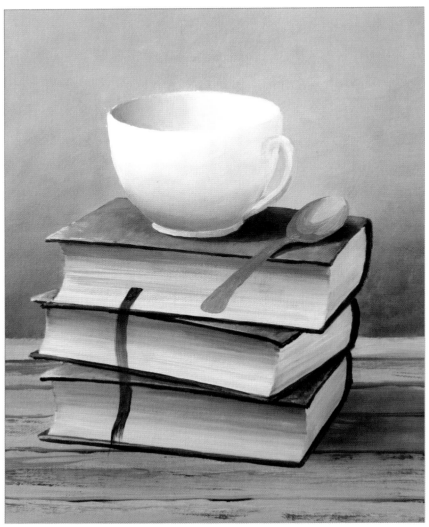

Step 9 Now it's time to turn my attention to the details in this still life setting: the bookmark and spoon. I place the bookmark using pure ultramarine blue; I will worry about refinement later. I start painting the spoon by re-creating its form with a medium gray tone.

FINISHING DETAILS

To give the bookmark a silky appearance, I mix white into the blue for highlights, adding gray for shadows. On the spoon, I mix pine gray with burnt sienna for a dark metal base. Then I touch in reflections, mixing white with both blues.

Bookmark 1 Bookmark 2

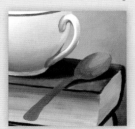

Spoon 1 Spoon 2

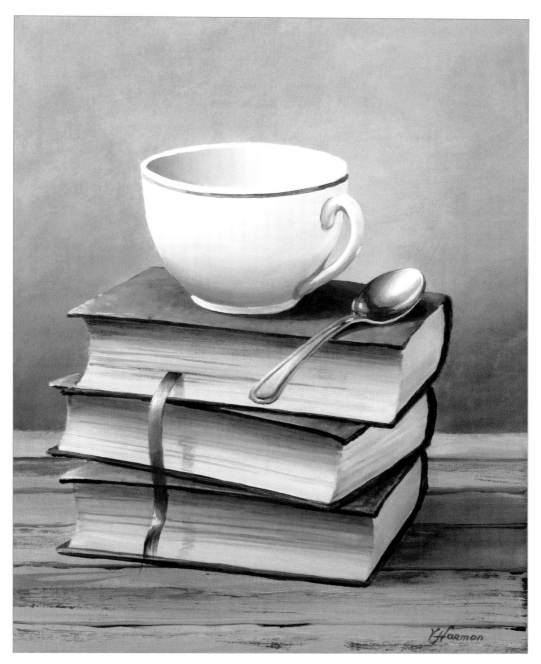

Step 10 The finishing touches are the refining details. In addition to completing the spoon and bookmark (see "Finishing Details" on page 26), I spend a little more time on the cup. I re-establish the shadows on the handle and touch up the reflections on the bottom of the cup, in both cases mixing a bit of ultramarine blue with white. With a slightly darker mix, I also paint the line around the rim of the china.

CAPTURING NATURAL LIGHT

The same variations that make natural light so interesting also make it challenging to capture. In the studio, light remains consistent and unchanging; outside, it is in continual flux. Cloud cover, time of day, and even wind can change the look of your subject. Taking photos of a natural-light still life allows you to work at your own pace; that way, even when conditions change, you have a record to refer back to.

Palette
alizarin crimson • burnt sienna • cadmium yellow medium • cerulean blue • pine gray • sap green
titanium white • ultramarine blue • yellow ochre

Step 1 I begin by drawing on a 12" x 16" canvas with a graphite pencil, tracing over the lines with gray paint once I'm happy with the composition. I establish a value sketch as part of the underpainting, using a thin layer of pine gray to work out the placement of the values.

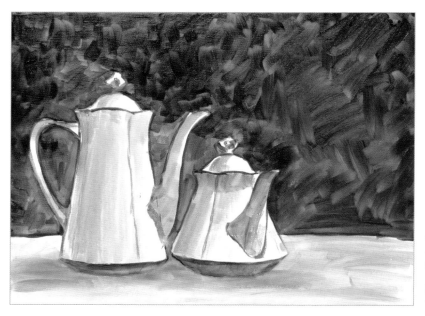

Step 2 I start applying color by roughly layering impressionistic brushstrokes for the background trees, using a limited palette of sap green, ultramarine blue, and pine gray. For the shadows on the table, I use a mix ultramarine blue, pine gray, and titanium white.

Step 3 I develop the background, mixing sap green, yellow ochre, and cadmium yellow medium for highlights and sap green, ultramarine blue, and pine gray for shadows. I use a mix of cerulean blue and white to create the illusion of sky. I also layer over the table and pots, mixing white with ultramarine blue and pine gray for more shadowed parts and cadmium yellow medium for warmer sunlit portions.

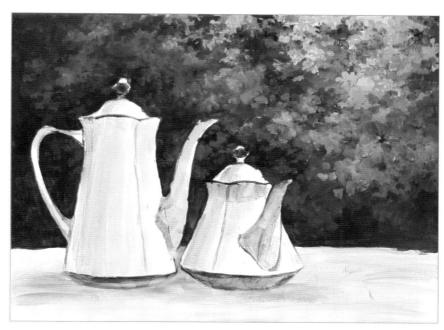

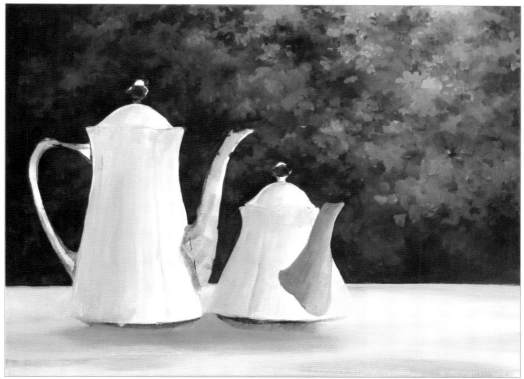

Step 4 To soften the sharp detail, I layer over the background with several thin washes, using cadmium yellow medium on the sunlit branches and ultramarine blue to tone down shadier portions. I continue developing the table and pots as well. For these layers, I focus on the overall shape and shadows using only three colors: ultramarine blue, alizarin crimson, and titanium white.

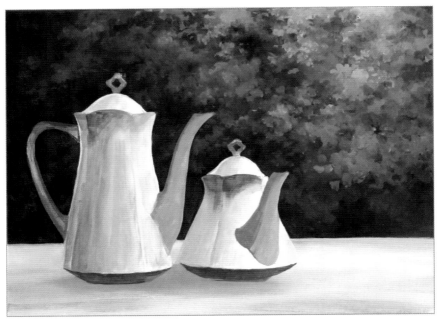

Step 5 Next I want to develop more contrast in the pots, so I focus on the dark shadows. I pick up my previous mix of ultramarine blue, alizarin crimson, and white from step 4, this time adding pine gray. With the same mix, I add detail to the coffeepot tops.

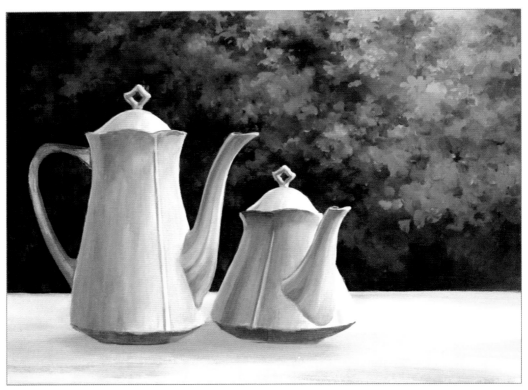

Step 6 Now I focus on establishing a smooth transition from light to dark and warm to cool. Beginning with the lightest areas on the right side of the pots, I apply a mix of cadmium yellow medium and titanium white. I mix in a bit of alizarin crimson as I work toward the shadows and then transition to a mix of ultramarine blue, pine gray, and titanium white with a hint of alizarin crimson in the darkest shadows.

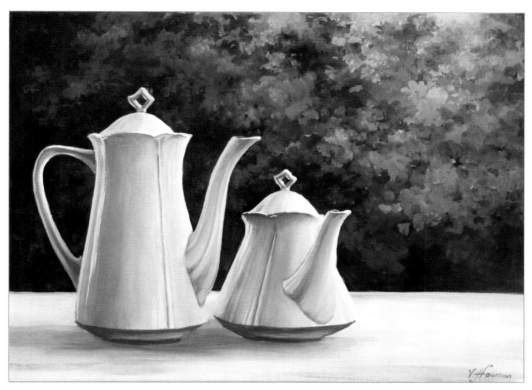

Step 7 To establish the curved form of the coffeepot handle, I apply the same light to dark transition technique and colors that I used on the pots in step 6. I warm the light areas applied in step 6 with yellow, reflecting the light source (the sun). But there are secondary highlight areas of cooler light as well. To add these reflections, I mix cerulean blue with titanium white. I finish the pot bottoms using ultramarine blue mixed with titanium white, pine gray, and a hint of alizarin crimson. Then I touch in a fine line of light reflection along the pot tops. I finish with another layer of highlight and shadow on the tablecloth.

DETAIL

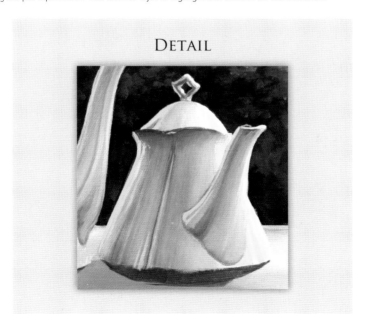

FEATURING TEXTURES

The reflections on smooth, shiny objects hold a strong visual appeal, but so do the natural variations and inconsistencies of textured objects. Including multiple objects with varying textures produces an even greater level of interest, thanks to the contrast, as shown in this example of vintage pots against a cracked wall with exposed brick.

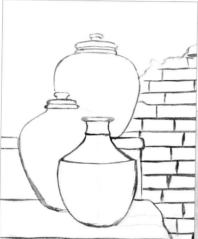

Step 1 When I sketch the basic shapes on my 12" x 16" canvas (first with pencil, then with gray paint), I also take the time to determine the parts of my composition that matter most, establishing where I'll be focusing my attention to detail.

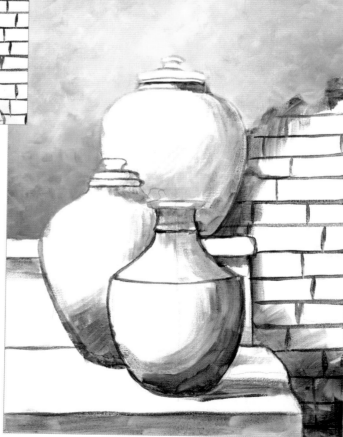

Step 2 After washing in shadow placement with a thin layer of pine gray, I turn my attention to the wall. For the first layer, I combine yellow ochre, burnt sienna, ultramarine blue, and titanium white. Next, to age the wall, I somewhat randomly and unevenly touch in a variety of colors from my palette.

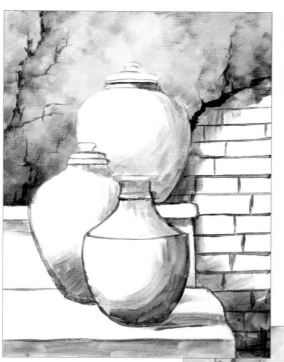

Step 3 To make the wall more interesting, I add a rough texture to its surface. I use the same random, uneven selection of colors from step 2, this time drybrushing the paint onto the canvas. I also paint in deep cracks, using a mix of burnt sienna and ultramarine blue.

Step 4 For the bricks, I begin with a burgundy underpainting. I apply a mixture of burnt sienna and ultramarine blue, using more blue in the shadows. The underpainting will speed up painting by establishing the value and direction of subsequent layers.

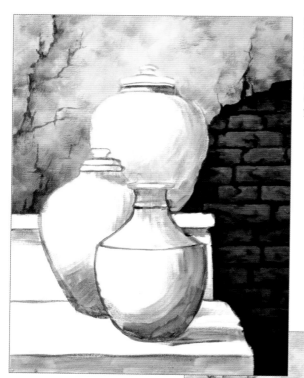

Step 5 My initial sketch will help me immensely here, because I paint each brick individually. Although I use a base mix of burnt sienna and ultramarine blue, this building is so old that the bricks are uneven in shape, size, and color; so I also create variations with alizarin crimson, yellow ochre, and titanium white.

Step 6 For the top pot, I mix varying proportions of ultramarine blue, yellow ochre, burnt sienna, pine gray, and titanium white, laying down a loose underpainting before layering on value transitions. For lighter values, I include more yellow and white in the mix, colors that gradually decrease as the blue and gray increase in the shadows.

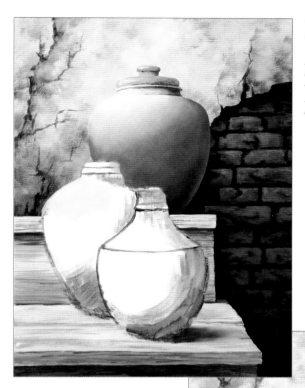

Step 7 I don't want to accidentally paint over the pot edges after they're finished, so I take a moment to focus on the shelves. As with the wall, I use a mix of yellow ochre, burnt sienna, ultramarine blue, and titanium white; however, I use more blue and white for a lighter, grayer tone, with even more blue in the shadows.

Step 8 The two foremost pots have similar color bases. I underlay a combination of ultramarine blue, yellow ochre, burnt sienna, pine gray, and titanium white for both, adding a little alizarin crimson to the middle pot for its clay color. For the oxidized areas of the copper pot, I also mix in sap green. As with the first pot, these underlayers include light to dark transitions with slight variations in the color mix proportions.

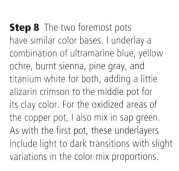

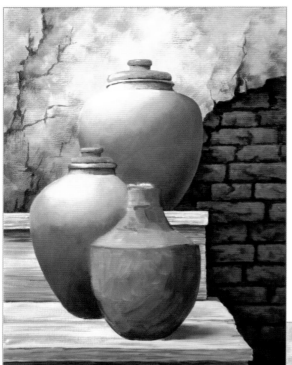

Step 9 I like working from the background forward, even when it comes to detail. So my next move is to refine the clay pot in the middle, painting its cover with a base of yellow ochre and adding in minor portions of burnt sienna and ultramarine blue.

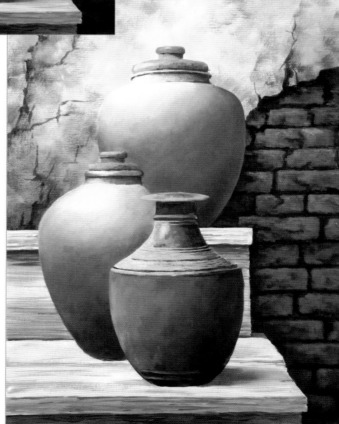

Step 10 Turning my attention to the copper pot's development, I mix ultramarine blue and burnt sienna for a layering base; then I add a bit of titanium white for the lighter areas. In the oxidized portions, I mix sap green, yellow ochre, ultramarine blue, and white.

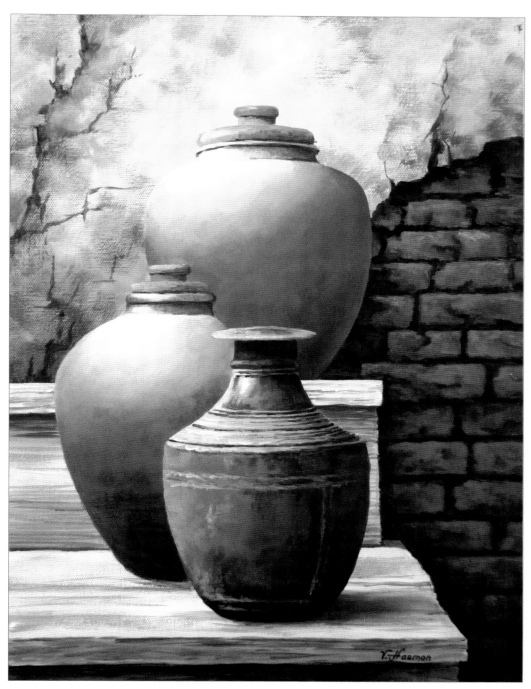

Step 11 To give the copper pot more character, I add a patina-laced surface detail. Working with the same mix as in step 10, I vary the color proportions to distinguish light from shadow. I also add a rougher texture to the shelf for greater contrast.

SHAPING WITH SHADOW

Pastry chefs can create frosting flourishes with a flip of the wrist. With just a little practice, you'll be able to paint them with the same ease. The trick is to focus on the shadows. When you learn to place highlights and shadows appropriately, subjects take on dimension and a lifelike appeal!

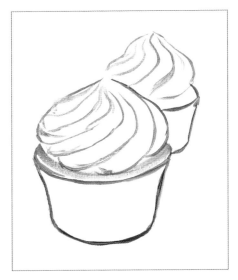

Palette
alizarin crimson • burnt sienna
cadmium yellow medium • titanium white
ultramarine blue • yellow ochre

Step 1 I work out this fairly simple composition directly on a 8" x 10" canvas using a ¼" flat brush. To establish the color scheme, I use yellow ochre for the cakes, mix in burnt sienna for the cup, and apply alizarin crimson and ultramarine blue for the frosting.

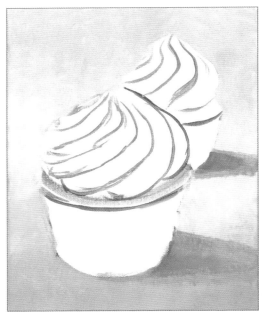

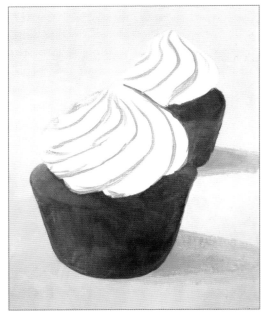

Step 2 For the background, I work from top to bottom, starting with a mix of ultramarine blue and titanium white. I transition to burnt sienna with a bit of alizarin crimson for the lower half. In areas where I want to achieve a shadow effect, I use less white in the mixes.

Step 3 Using the same brush, I paint the cakes—including what will be the liner—starting with mostly yellow ochre on the left, facing the light, and gradually adding more burnt sienna on the right as the cakes move into shadow. For the darkest part, I mix in a bit of ultramarine blue.

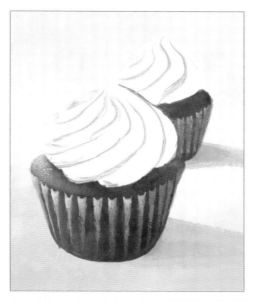

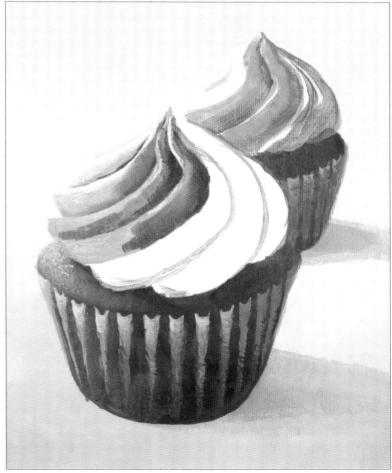

I hold on to old brushes, like this small round brush. It's lost its shape, making the bristles perfect for applying specks of yellow ochre and white that look like dappled light.

Step 4 Next I add highlights to the top of the cake on the left (see detail). I also define the paper liners with the ¼" flat brush. At the top of each paper ridge, I apply a mix of yellow ochre and titanium white. As I move down, I reduce the white in the mix and narrow the width of the folds, blending the liner color with the cake color when I reach the base.

Step 5 You have two options for the frosting. (See page 40 for an alternative approach.) Here, with the ¼" flat brush, I paint each swirl individually. I begin with a medium-tone mix of ultramarine blue, alizarin crimson, and titanium white. On top of this, I apply shadows, using less white in the mix. Then I define highlights, using white with a touch of ultramarine blue.

FROSTING DETAIL

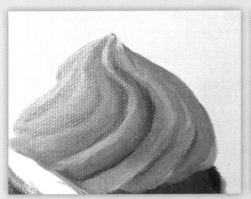 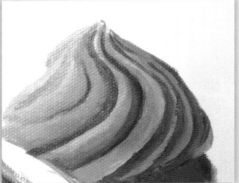

Step 1 You also can approach the frosting as one shape. Mix a medium tone of ultramarine blue, alizarin crimson, and titanium white to add guidelines showing the direction of the swirls. Then paint from left to right, using less white as you move into shadow.

Step 2 Next add more dimension to the swirls with shading. I use the same mixture from the previous step, but with more white. I also add more alizarin crimson for a pinkish tone in the lighter areas on the left and more blue for the darker shadows at right.

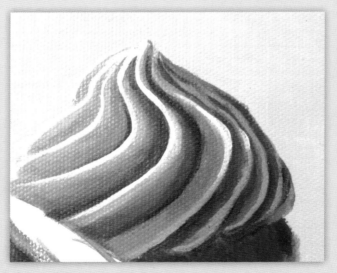

Step 3 The last step is to add highlights along the ridges of the swirls where the light hits the frosting. I use pure titanium white for the spots where the light hits directly, but I add ultramarine blue to tone down the white for highlights in the areas of heavier shadow.

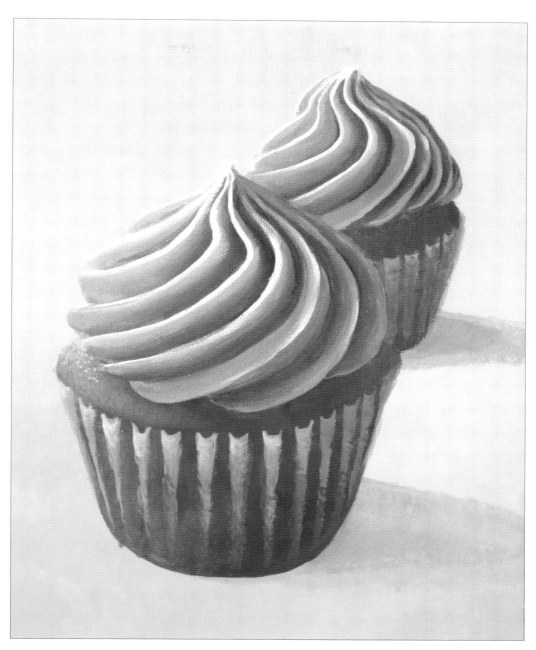

Step 6 When you've finished frosting one cake, move on to the next. I approached the frosting on the cupcake in the foreground with individual swirls and the frosting on the cupcake in the background as a whole. Both methods yield frosting that looks good enough to eat. All we need now is sprinkles!

Sprinkles Detail

Step 1 I dot each sprinkle into place with a medium-tone mixture of alizarin crimson and titanium white, using a small, round brush.

Step 2 To give the dots shape, I add shadows, touching alizarin crimson to the bottom of each sprinkle. I also throw a shadow beside each sprinkle with the frosting palette from step 5 on page 39.

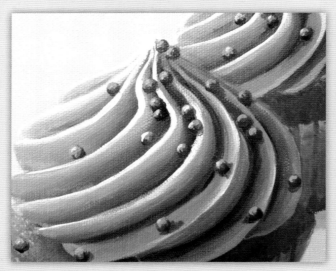

Step 3 To complete the three-dimensional look of the small balls, I add highlights. Here, where the light is shining, a small touch of white to the left is all that's needed.

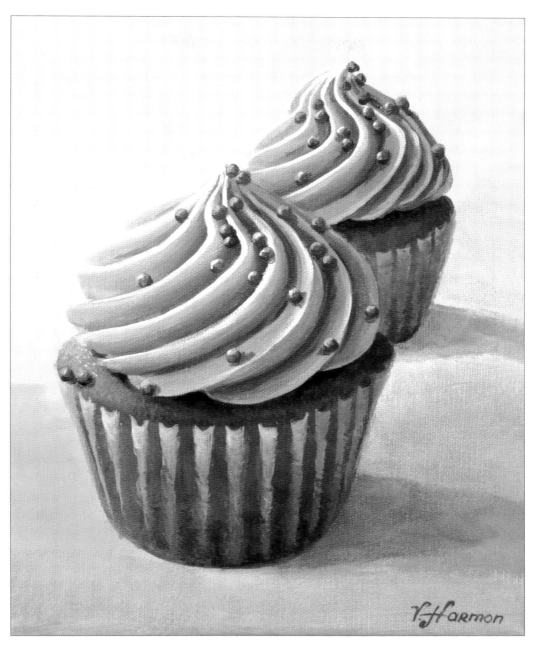

Step 7 The sprinkles aren't the only decorations that cast shadows; the frosting also casts a shadow on the top of each cake. I return with a little yellow ochre mixed with burnt sienna to add these. To finish, I emphasize the shadows cast from the cupcakes on the table, layering on alizarin crimson mixed with burnt sienna and a little titanium white.

DEVELOPING RICH COLOR

Many people associate deep, vivid color with thick painting techniques. But you can achieve bright, vibrant shades with thinner applications of paint as well. When you layer washes one on top of another, rich color with a lot of interest is the result thanks to the dynamic variations layering allows you to introduce.

Palette
alizarin crimson • burnt sienna • cadmium red medium • cadmium yellow medium • raw umber
sap green • titanium white • ultramarine blue • yellow ochre

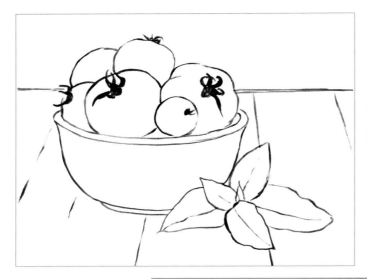

Step 1 Sketches don't need to include minute detail. But the shape of tomato sepals and stems can be tricky, so I work them out as I prep my sketch on the 11" x 14" canvas.

Step 2 I create a template for the values of the painting, using a thin layer of raw umber. To keep the background dynamic, I create an uneven mix on my palette, combining raw umber, ultramarine blue, sap green, yellow ochre, cadmium yellow medium, and burnt sienna. I want each brushstroke to hold a slightly different color.

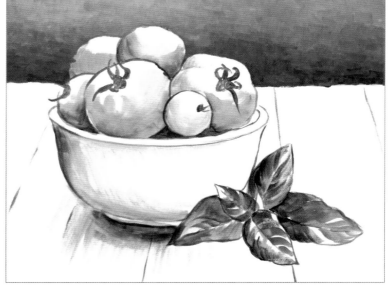

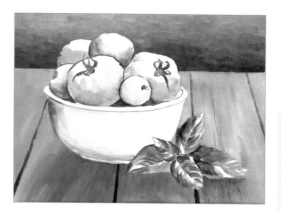

Step 3 For the table, I also want uneven color. I mix color on the canvas by picking up ultramarine blue, burnt sienna, raw umber, or yellow ochre on a 1" flat brush, painting a stroke, and then picking a different color and stroking directly over the first. To draw the lines between the boards, I mix burnt sienna, raw umber, and ultramarine blue.

DETAIL

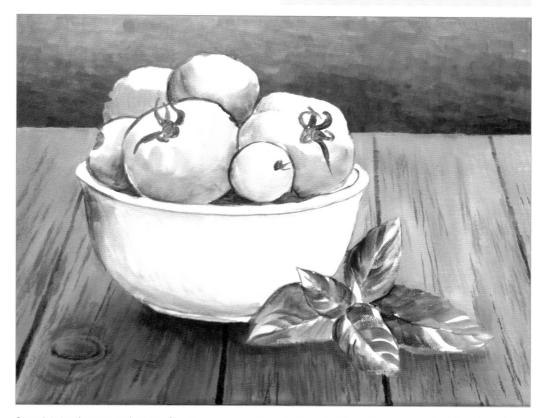

Step 4 Using the same combination of burnt sienna, raw umber, and ultramarine blue, but leaning toward a darker mix, I paint small cracks on the tops of the boards, pulling strokes down with the edge of the 1" flat brush. I also use this darker color to add knots and apply the cast shadows near the basil leaves and bowl.

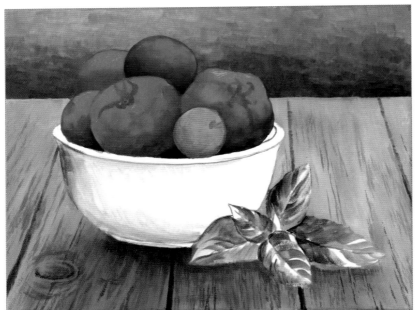

Step 5 Next I shift focus to the tomatoes. With the ¼" flat brush, I apply a layer of cadmium red medium to the lightest areas, adding raw umber and ultramarine blue as I work into the shaded portions. The smallest tomato gets a layer of cadmium yellow medium.

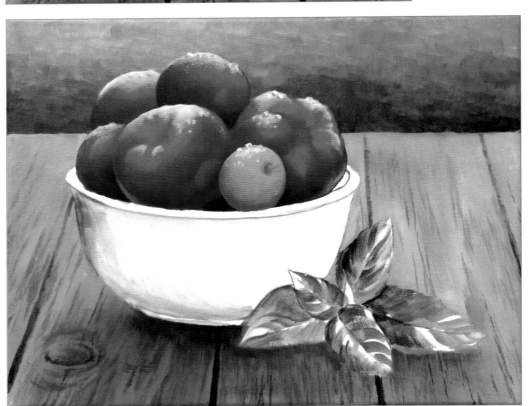

Step 6 When the first layer is dry, I revisit the tomatoes with the same color mix, adding a little ultramarine blue in the shaded areas. Then I mix cadmium red medium with titanium white to dot on light reflections and water drops (see "Layering the Tomatoes" on page 47).

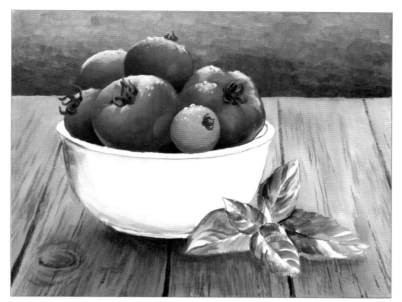

Step 7 With the base color complete, I move on to the stems and sepals of the fruit. For these, I mix sap green and burnt sienna for the main color. Then I switch to sap green and cadmium yellow medium for the highlights.

LAYERING THE TOMATOES

Step 1 The tomatoes should appear ripe and juicy. Watered-down washes won't do. If your color appears washed out, you may need to apply more than one additional layer.

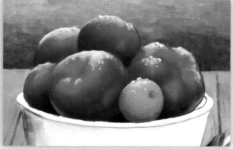

Step 2 My highlights all face the direction of the light source at top right. The water drops are distinguished because they don't all fit inside the fruit shapes; some sit on top.

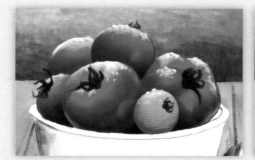

Step 3 Let the tomato color dry before applying the dark color of the stem and sepals. Follow the underpainting to guide the position and shape of these twisting details.

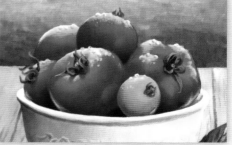

Step 4 Even sepals get highlights; it's what gives them dimension. Just as with the tomatoes, place the highlights carefully, all facing the direction of the light source.

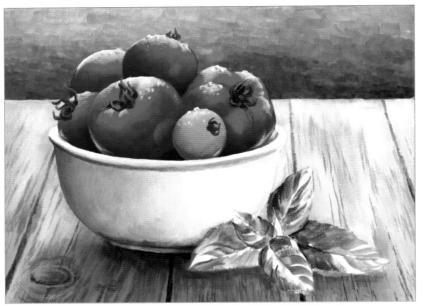

Step 8 The white bowl contains multiple colors thanks to its shadows and reflections. I mix a little cadmium yellow medium into titanium white on the lighter side of the bowl, adding a touch of sap green where the bowl reflects the basil. As I work toward the darker side, I add more and more ultramarine blue and raw umber, adding both shading and reflection from the table.

CREATING THE BASIL

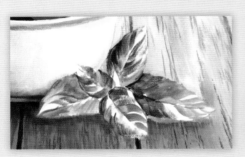

Step 1 The value sketch under my painting is a real help, as it provides a guide for the shadows and highlights that give the leaves both dimension and texture.

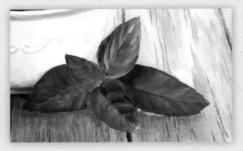

Step 2 For the first layer, I use a mix of sap green, ultramarine blue, and raw umber. But it isn't completely uniform. The color is lighter on the leaf directly affected by the light.

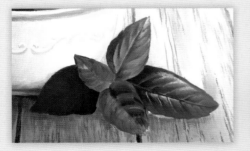

Step 3 I add another application of color to the shaded areas. When that dries, I apply highlight areas using a lighter mix of cadmium yellow medium, titanium white, and sap green.

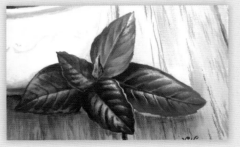

Step 4 In the shaded areas of the leaves, I touch in a bluish reflection of a secondary light source. I also highlight little lines along the edges of the leaves.

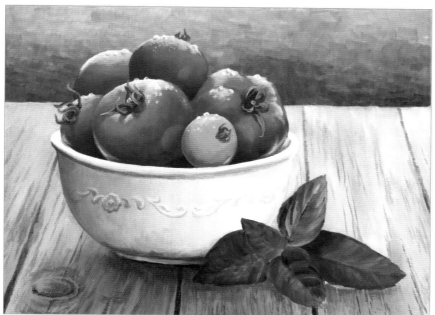

Step 9 I apply a raised design of swirls and flowers in a line across the middle of the bowl. With a small round brush, I paint the darker color first, using titanium white with ultramarine blue and raw umber. Then I define the pattern with lighter strokes, using titanium white and cadmium yellow medium. I also apply the first layer of sap green, ultramarine blue, and raw umber to the basil.

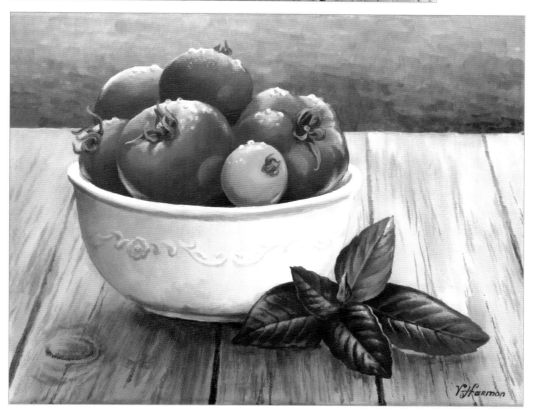

Step 10 I'm happy with all the features of my painting except the basil leaves, which require a few more layers to give them a fully developed appearance. (See "Creating the Basil" on page 48.) Once the basil is complete, so is the painting!

BALANCING WITH BACKGROUND

Some subjects are so complex, they beg for a simplistic backdrop. Others require a textured or colorful background to bring the painting to life. In every case, the background is as much part of the composition as the main subject. You can use it to contrast a subject, complement it, or even unify it, as I'll demonstrate here.

Palette

alizarin crimson • burnt sienna • cadmium red medium • cadmium yellow medium • pine gray
sap green • titanium white • ultramarine blue • yellow ochre

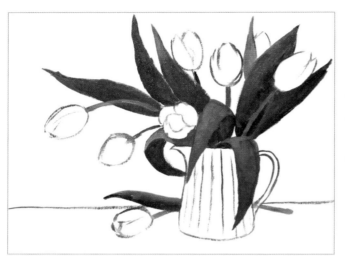

Step 1 I make a quick sketch with pine gray paint on a 14" x 18" canvas. I approach my underpainting in parts, beginning with the darkest. With a ¼" flat brush, I paint the leaves using sap green. In the lighter areas, I add a little cadmium yellow medium to the green; in the more shaded portions, I mix in ultramarine blue instead.

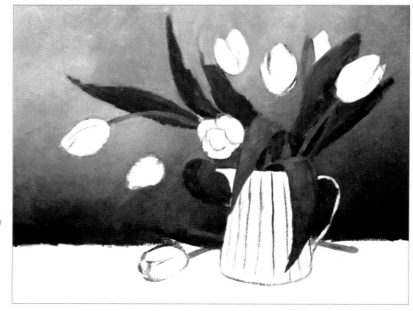

Step 2 Next I start at the top of the canvas to paint the first layer of the background. I begin with a warmer tone, mixing yellow ochre and burnt sienna, but as I move closer to the table, I eliminate the yellow ochre and gradually add ultramarine blue to the mix.

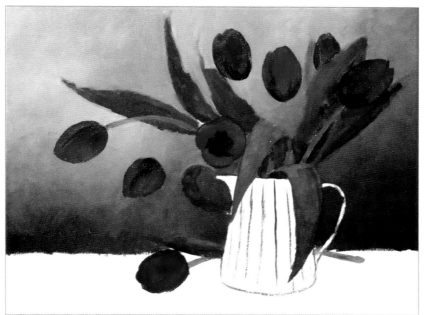

Step 3 The first layer of tulip color also varies according to shadow and highlight. For the lighter areas, I apply alizarin crimson mixed with cadmium red medium. As I move toward the shadowed areas, I add ultramarine blue for the darker tones.

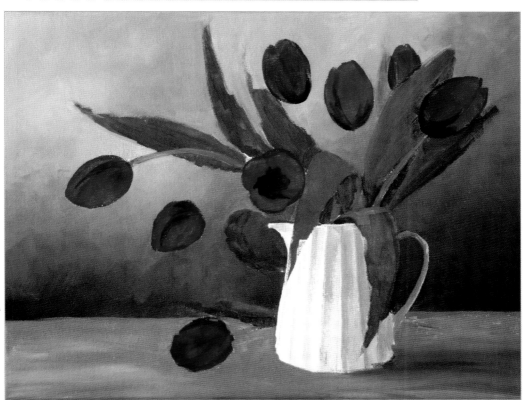

Step 4 I paint the table with a coat of yellow ochre and burnt sienna, with ultramarine blue mixed in for the shadow. The vase is mostly white, but I mix cadmium yellow medium with titanium white for the light side and alizarin crimson and ultramarine blue for the shadowed side.

Visual Blending

For the impressionistic background, I don't mix my paints on the palette. Instead, I apply separate, short strokes of color on the canvas, allowing the eye to visually blend the colors.

Step 1 Starting in the top left corner, I apply quick, short strokes of yellow ochre and titanium white, varying both the direction of the strokes and the balance of the two colors. Don't worry about covering every bit of space; the underpainting will show through any gaps.

Step 2 I continue with this method and these colors all across the top of the background, using the lighter underpainting as my map. Then, to create a reddish-brown appearance, I mix in burnt sienna brushstrokes, layering them right over the earlier strokes.

Step 3 To help smooth the visual transition that needs to occur from the light colors at the top of the wall to the darker colors at the bottom, I also layer in strokes of light purple. For these, I apply a combination of alizarin crimson, ultramarine blue, and titanium white.

Step 4 For the cooler, darker portions of the wall, I use pine gray, ultramarine blue, and titanium white, again varying the color portions, angle, and size with each stroke. Where the light-to-dark transition occurs, I touch a few darker strokes in with the lighter colors.

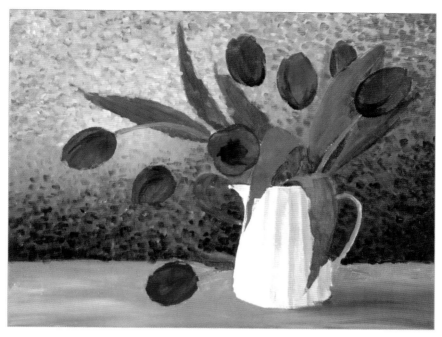

Step 5 When you've completed your background, step back to take a look. Close up, the individual strokes are very apparent. But as you step back, the eye begins to blend the colors together. The farther back you go, the greater the effect. At this stage in the painting process, you can modify the overall color by adding more strokes of any color or colors that you think might benefit the overall painting.

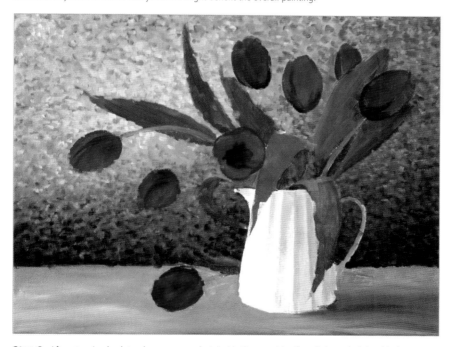

Step 6 After stepping back to observe my work, I decide the transition from light to dark is a bit sharp. To make the visual shift more natural, I stroke in more of the warm colors along the entire bottom of the wall. I also add more dark color into the transition zone.

DETAIL

I'm still tinkering with the background wall at this stage. This time, I decide that adding a few strokes of sap green will better reflect the tulips and unify the painting.

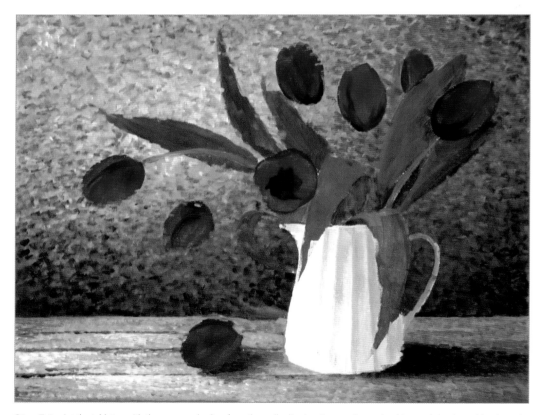

Step 7 I paint the tabletop with the same cool colors from the wall: alizarin crimson, ultramarine blue, and titanium white. I use the darker, cooler colors as well, but I apply the pine gray, ultramarine blue, and white only in the shadows cast by the tulip and vase.

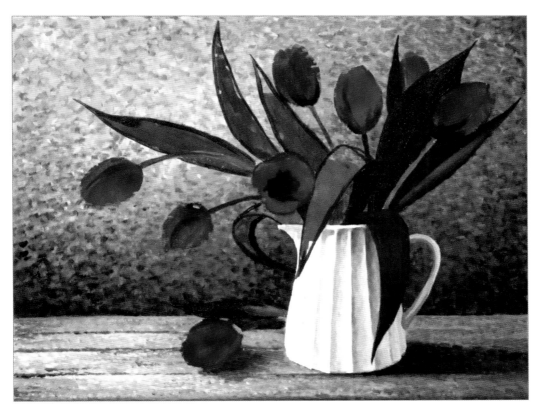

Step 8 While the sap green is still fresh on my brush, I take the opportunity to redefine the edges of the leaves. I inadvertently painted over parts of the leaves when I was quickly stroking in my background. Next I shift focus to develop the vase (see detail).

DETAIL

I paint the grooves of the vase, using cadmium yellow medium mixed with titanium white on the light side of each groove and alizarin crimson, ultramarine blue, and burnt sienna on the shadowed side. The lighter parts also reflect a little blue from a secondary light source.

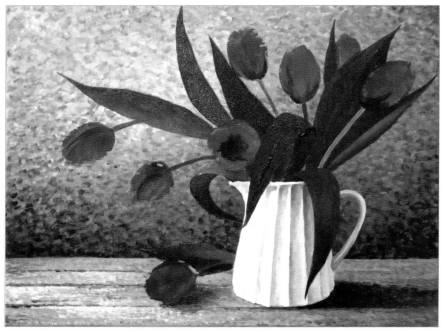

Step 9 With the edges redefined, I can paint in the shaded portions of the tulip leaves and stems. I mix sap green and ultramarine blue and fill them in with the ¼" flat brush.

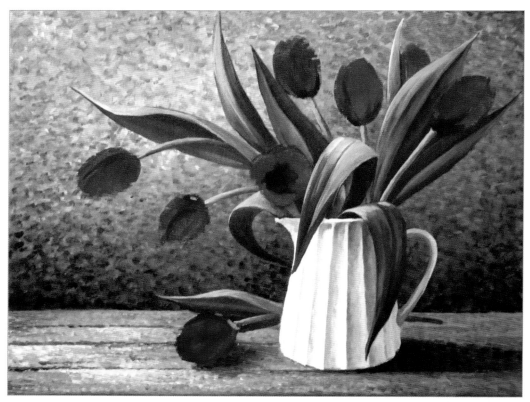

Step 10 Now I bring out more detail in the stems and leaves by adding lighter portions with a mix of cadmium yellow medium, titanium white, and sap green.

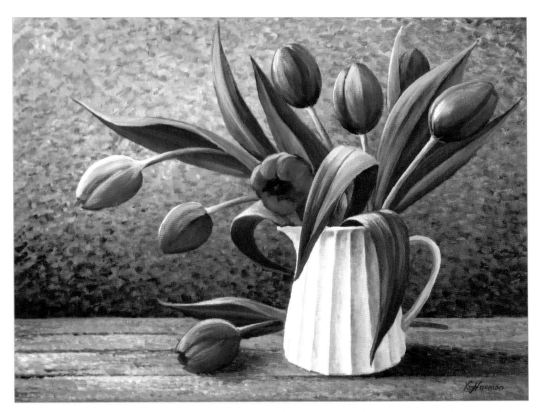

Step 11 Everything is complete now except for the flowers. I cover the underpainting with a dark layer of alizarin crimson mixed with ultramarine blue to establish the shadows. Then I apply cadmium red medium on the petals to create a transparent effect. I finish with the highlights, using a mixture of cadmium yellow medium and titanium white.

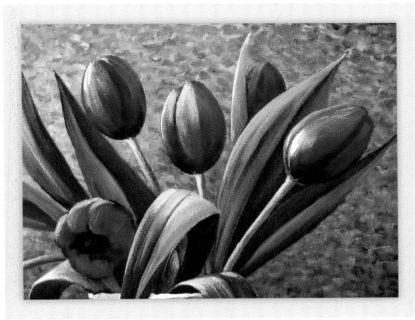

DETAIL

The tulips are the focal point of this painting, so attention to detail is important. Be especially mindful of the direction of the light source when applying the highlights.

CREATING REALISM

When you're working with everyday subjects like a bowl of fruit, accuracy is essential. After all, everyone knows what a banana looks like in real life. One way to ensure accuracy is with the use of highlight and shadow to create realistic shape and form. Another is to produce lifelike textures with brushstroke techniques, such as drybrushing.

> **Palette**
> alizarin crimson • burnt sienna • cadmium yellow medium • raw umber • sap green
> titanium white • ultramarine blue • yellow ochre

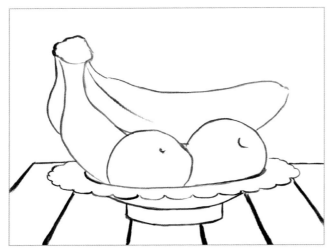

Step 1 To build self-confidence when painting more unusual shapes, like these bananas, work out the sketch on a piece of paper before drawing on the 11" x 14" canvas.

Step 2 Applying light and dark tones correctly will help me give lifelike form and dimension to the round fruit. I apply a thin layer of raw umber to establish the values. With a 1" flat brush, I paint the background wall, varying the direction of my strokes and also the shades of gray. I use a base of mostly titanium white, mixing in varying proportions of yellow ochre, burnt sienna, and ultramarine blue to create interest.

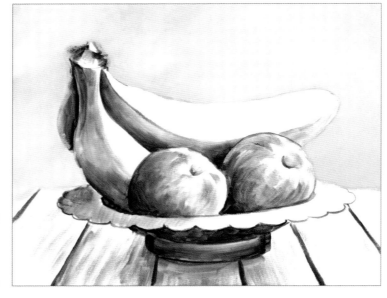

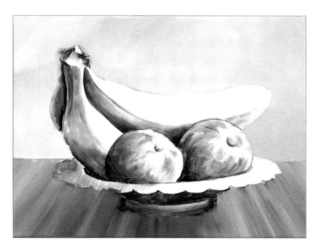

Step 3 I also want variety in the tabletop to give it a natural, woodgrain appearance. For this uneven mix, I alternate picking up burnt sienna, raw umber, or yellow ochre on the 1" flat brush, overlapping the colors on the canvas to combine them as I stroke downward.

Step 4 To finish the table, I pick up a dry 1" flat brush, lightly touching the canvas as I drag down a burnt sienna and raw umber mix that hasn't been diluted with water. The drybrush technique creates long strokes with the texture of rough wood. I also add lines between the boards with a mix of burnt sienna, raw umber, and ultramarine blue.

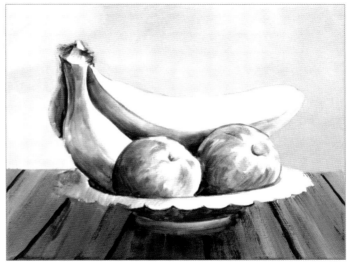

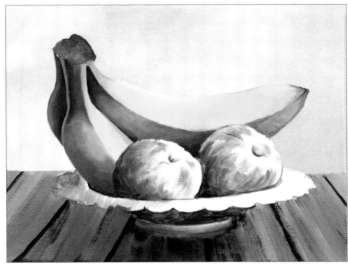

Step 5 For the bananas, I apply cadmium yellow medium with yellow ochre in the lighter areas, adding a little sap green in places. I mix in burnt sienna for the main part of the fruit, adding more for the shadows. For the tops of the stems, I mix raw umber with burnt sienna.

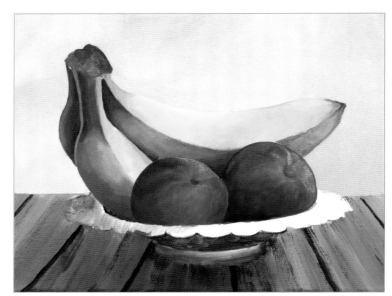

Step 6 Using my ¼" flat brush, I apply the first layer to the nectarines, mixing alizarin crimson and burnt sienna for the base color. I add a hint of cadmium yellow medium in the lightest parts. For the shaded areas, I mix the base color with ultramarine blue.

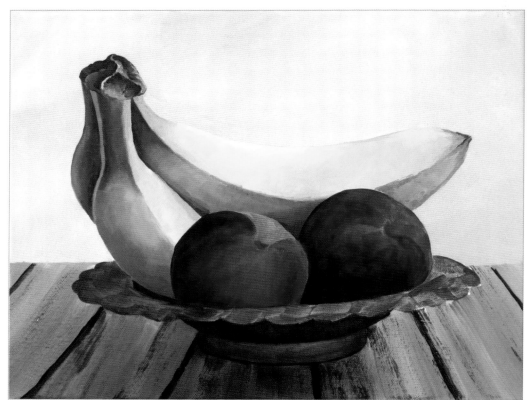

Step 7 I use two mixes for the bowl underpainting. The flat rim is burnt sienna, ultramarine blue, and raw umber mixed with a little alizarin crimson and titanium white. The base is a much darker mix of burnt sienna, raw umber, and ultramarine blue. I apply ultramarine blue mixed with raw umber to the tops of the banana stems with a small round brush. I add burnt sienna, yellow ochre, and titanium white in the lighter areas, varying the temperature. I also apply deeper color to the nectarines with a mix of alizarin crimson and burnt sienna, adding ultramarine blue in the shaded areas.

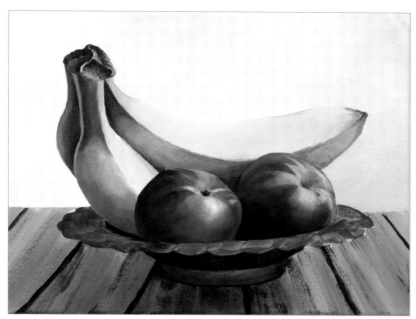

Step 8 When the nectarines are dry, I apply the lighter colors, mostly using a dry brush and little or no water mixed with the paints. I start with yellow ochre mixed with titanium white. Then I add light blue reflections with a mix of ultramarine blue and white.

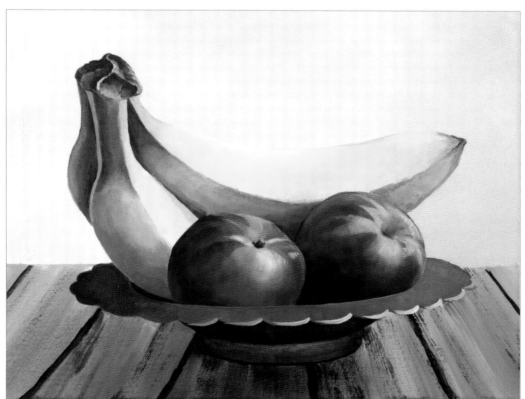

Step 9 Using the same colors from step 7, I add a second layer of paint to the bowl. To show light reflections on the bowl's rim, I mix ultramarine blue and titanium white. The main light source is on the right, so the reflections on the right side are lighter than on the left. They become gradually darker before completely disappearing within the shaded area.

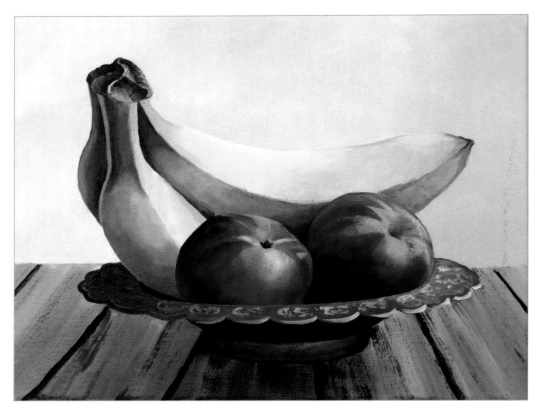

Step 10 The bowl has some of the same light reflections as the nectarines, so I pick up the same light blue mix of ultramarine blue and white from step 8 to apply the openwork details on the flat rim of the bowl. I add more blue to the mix in the shadows.

ARTIST'S TIP

The openwork design of the bowl may look complex.
Just take it step by step, and you'll be surprised how simple it is.

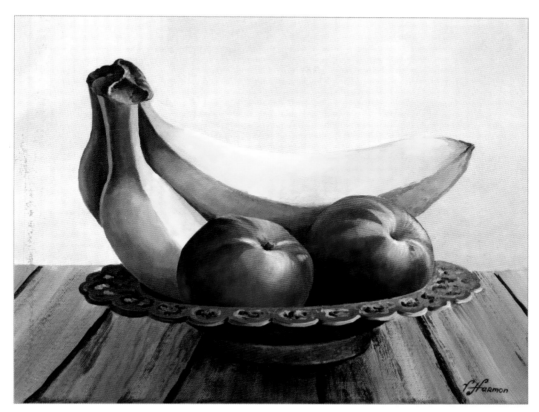

Step 11 For the small holes in the openwork, I apply colors as they would be seen through the gaps. For example, the darker colors of the bowl's bottom show through the holes in the middle. On the left and right sides of the bowl, the table shows through. Turning my attention to the bottom of the bowl, I apply a mix of ultramarine blue with a little titanium white in the light areas. The top of the fruit bowl also still needs a little shading along the outside edge, where I apply burnt sienna mixed with raw umber.

CLOSING THOUGHTS

One idea proven by many great artists is that practice makes all the difference. Don't get discouraged if you make mistakes at first and don't get the results you desire. Although it may be difficult, try to see each mistake as a valuable lesson that will bring you closer to your goal. Remember that exercising your skills, even in small ways, will improve your talents as an artist over time.

Some artists do not especially like to paint still life; however, it is a great way to learn aspects of the painting process that can then be applied to painting other subject matter. Once you gain confidence in your talent, along with the knowledge of good composition, value, light source, color, and temperature, you will be able to create your own masterpieces.

Have fun, and enjoy every moment of your artistic journey!

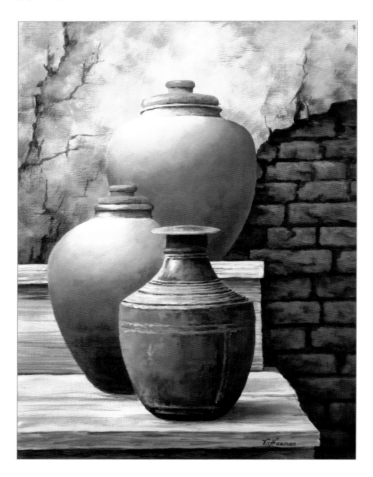